ATHENS, STILI

Athens, Still Remains

The Photographs of Jean-François Bonhomme

JACQUES DERRIDA

Translated by Pascale-Anne Brault and Michael Naas

FORDHAM UNIVERSITY PRESS NEW YORK 2010

Athens, Still Remains was published in French as *Demeure, Athènes*
by Éditions Galilée, © 2009 Éditions Galilée.

Library of Congress Cataloging-in-Publication Data

Derrida, Jacques.

[Demeure, Athènes. English]

Athens, still remains : the photographs of Jean-François Bonhomme /
Jacques Derrida ; translated by Pascale-Anne Brault and Michael Naas.

p. cm.

Includes bibliographical references.
ISBN 978-0-8232-3205-5 (cloth : alk. paper) —
ISBN 978-0-8232-3206-2 (pbk. : alk. paper)

1. Death. 2. Grief. 3. Sepulchral monuments—Greece—Athens—Pictorial
works. 4. Athens (Greece)—Antiquities—Pictorial works. I. Bonhomme,
Jean-François, 1943– II. Brault, Pascale-Anne. III. Naas,
Michael. IV. Title.

BD444.D465313 2010

194—dc22

2010020610

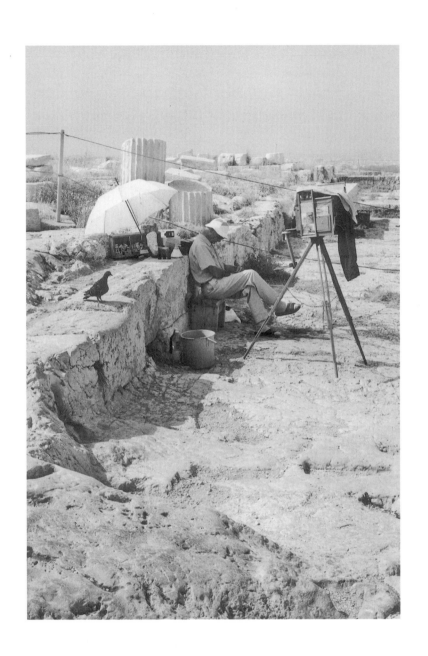

Contents

Illustrations

Translators' Note

Athens, Still Remains (*Demeure, Athènes*) was first published in 1996 by Editions OLKOS (Athens) in a bilingual French–Modern Greek edition. It appeared there as the preface to a collection of photographs by Jean-François Bonhomme published under the title *Athens—in the Shadow of the Acropolis* (*Athènes—à l'ombre de l'Acropole*). Derrida's preface was subsequently published alone in French, along with Bonhomme's photographs, by Éditions Galilée in 2009. This English translation is based on the Galilée edition.

Derrida's original French title, *Demeure, Athènes*, can be heard in at least three different ways: as an imperative, "Stay, Athens!" as a description, "Athens stays" or "Athens remains," or as a formulation typically found on official documents to refer to one's place of residence, "Residence: Athens." The word *demeure* can thus be heard either as a noun, meaning house, dwelling, or residence, or as a verb, meaning to remain, stay, or reside. The verb *demeurer* also originally meant "to defer" or "to delay." Derrida exploits all of these meanings in this work, along with a number of related idioms. Because no single English word or even phrase can cover all the different meanings or valences of the French *demeure*, the title *Athens, Still Remains* is less a translation than a transposition into a semantic field that is akin to the original but overlaps it only partially.

Parts of this work were translated by David Wills and published in his translation of Jacques Derrida and Catherine Malabou's *Counterpath: Traveling with Jacques Derrida* (Stanford: Stanford University Press, 2004, 103–8). We are grateful to David Wills for allowing us to adopt so many of his felicitous word choices.

A graduate seminar in the Philosophy Department at DePaul University in autumn 2009 allowed us to refine and improve this translation. We would like to express our gratitude to the members of the seminar, as well as to our colleague at DePaul, Elizabeth Rottenberg, for their many excellent suggestions.

Finally, we would like to thank the Summer Grants Program of the College of Liberal Arts and Sciences at DePaul University for its generous support of this project.

ATHENS, STILL REMAINS

Nous nous devons à la mort.

Nous nous devons à la mort.[1]

We owe ourselves to death.

It was this past July 3, right around noon, close to Athens.

It was then that this sentence took me by surprise, in the light—"we owe ourselves to death"—and the desire immediately overcame me to engrave it in stone, without delay: a snapshot [*un instantané*], I said to myself, without any further delay.

As the figure of an example, no doubt, but as if it had prescribed to me these words in advance, what immediately flashed before me was one of these photographs: *Kerameikos Cemetery, Street of Tombs, Sepulcher* (no. 1): on the distended skin of an erection, just below the prepuce, a sort of phallic column bears an inscription that I had not yet deciphered, except for the proper name, Apollodorus. And what if it were *that* Apollodorus, the author of a history of the gods? I would have loved to sign these words; I would have loved to be the author of an epitaph for the author of a history of the gods.

I had been traveling in Greece with these photographs ever since Jean-François Bonhomme had given them to me. A risk had already been taken when I promised to write something for the publication of these photographs, and I had already begun to approach them with the familiarity of a neophyte, where fascination, admiration, and astonishment were all bound up together, all sorts of troubling questions as well, in particular regarding the form my text might take. Without knowing it, I must have decided on that day, the third of July, having not yet written a word, that the form would be at once *aphoristic* and *serial*. Making use in this way of black and white, shadow and light, I would thus disperse my "points of view" or "perspectives," all the while pretending to gather them together in the sequence of their very separation, a bit like a narrative always on the verge of being interrupted, but

also like those funerary stones standing upright in the *Street of Tombs* (no. 26). Around the one on which the name Apollodorus could be read, I had already noticed the insistence of a serial motif. Back and forth from one to the other, from one column to another and one limit or turning point to the next, this seriality *is in mourning* or *bears mourning* [porte le deuil]. It bears mourning through its discrete structure (interruption, separation, repetition, survival); it bears the mourning *of itself, all by itself*, beyond the things of death that form its theme, if you will, or the content of the images. It's not just in the Kerameikos Cemetery or among its funerary steles that this can be seen. Whether we are looking at the whole picture or just a detail, never do any of these photographs fail to signify death. Each signifies death without saying it. Each one, in any case, recalls a death that has already occurred, or one that is promised or threatening, a sepulchral monumentality, memory in the figure of ruin. A book of epitaphs, in short, which *bears* or *wears mourning* [porte le deuil] in photographic effigy. (*Porter le deuil*— what a strange idiom: how is one to translate such a bearing or such a range of meaning [*portée*]? And how is one to suggest that the dead, far from being borne by the survivor, who, as we say, goes into mourning or bears mourning, is actually the one who first bears it, bears it within or comprehends it like a specter that is greater than the "living" heir, who still believes that he contains or comprehends death, interiorizing or saving the departed whose mourning he must bear?) We thus get the impression that what I have ventured to call, without too much impudence, the phallus or the colossus of Apollodorus immediately becomes the metonymic figure for the entire series of photographs collected in this book. But each one of them remains in its turn what it becomes: a funerary inscription with a proper name. Having to keep what it loses, namely the *departed*, does not every photograph act in effect *through* the bereaved experience of such a proper name, through

the irresistible singularity of its referent, its here-now, its date? And thus through the irresistible singularity of its *rapport with* or *relation to* what it shows, its *ferance* or its bearing, the *portée* that constitutes its proper visibility? It thus seems impossible, and that's the whole paradox, to stop this metonymic substitution. There is nothing but proper names, and yet everything remains metonymic. That's photography: seriality does not come to affect it by accident. What is accidental is, for it, essential and ineluctable: My feeling was to be confirmed as it came into sharper focus. Yes, each photograph whispers a proper name, but it also becomes the appellation of all the others. You can already verify this: without compromising in the least its absolute independence, each of them is what it is, no doubt, all on its own, but each one calls at once *some* other one and *all* the others. I will be able to say this better later. Whence the idea of a series of aphorisms analogous to the multiple tries or takes of the amateur photographer I am, a stream of snapshots or stills [*clichés*][2]—now there's a possible title—sometimes just negatives waiting to be developed. Here and there a few enlargements— of the "thing" itself or of a detail. I would thus allow myself a series of trials and errors: to prolong in one place the time of the pose, to multiply in another various "zooms" or discontinuous close-ups of the same place, affording myself the liberty to feel my way as I go, to multiply the stereotypes and the polaroids, to retrace my own steps, to take a shadow by surprise—and always to own up to my inexperience: inept framing, overexposure, underexposure, shooting into the light, and so on. (Speaking of which, what would Plato or Heidegger have thought of this thing called the shutter or, in French, using a name that has been part of the vocabulary of photography since 1868, the *obturateur*? Would they have even considered this little mechanism that allows one to calculate the light passing through, the impression of the sensible subjectile—and the delaying of the "right moment" [*moment voulu*].)

Still I

We owe ourselves to death.

What a sentence. Will it be more or less sententious for being fixed or focused on in this way by a lens or objective, as if one were to let it sink back just as soon, without any celebration, into the nocturnal anonymity of its origin? We owe ourselves to death. Once and for all, one time for all times. The sentence took me by surprise, as I said, but I knew right away that it must have been waiting for me for centuries, lurking in the shadows, knowing in advance where to find me (where *to find* me? What does that mean?). And yet—and I would be prepared to swear to this—it appeared only once. Never does it lend itself to commentary, never does it specify its modality: is it an observation or a piece of advice, "we owe ourselves to death"? Does this sentence express the law of what *is* or the law that prescribes what *ought to be*? Does it let us hear that, in fact or in truth, we owe ourselves to death? Or else that we are obliged, that we ought, to owe ourselves to death? For it came to me, so to speak, only once, this oracular thing, this one and not another, only one time, the first and last time at the same time, on a certain day in July, and at a certain moment, and every time I make it come back, or rather each time I let it reappear, it is *once and for all*, *one time for all times*, or rather I should say: all the times for a single time. Like death. (One might insert here a short treatise on the *idealization of ideality*—or on ideal objectivity—through the iterability of the "one time for all times," and, to stay in Greece, introduce the question of photography, between Plato and Husserl, in the context of what *eidos* will have meant.)

Tell me, who will ever have photographed a sentence? And its silence of things stifled on the surface? Who will ever have photographed anything other than this silence?

Having surfaced from who knows where, the sentence in question no longer belonged to me. It had, in fact, never been mine, and I did not

yet feel responsible for it. Having instantly fallen into the public do-
main, it had traversed me. It passed through me, saying from within
me that it was just passing through. Having become its hostage rather
than its host, I had to offer it hospitality, indeed, to keep it safe; I was,
to be sure, responsible for its safekeeping, for safeguarding each of its
words, accountable for the immunity or indemnity of each letter joined
to the next. But the same debt, the same obligation, dictated to me that
I not take this sentence, not take it as a whole, that I not under any cir-
cumstances take hold of it like a sentence signed by me. And it did in
fact remain impregnable.

This acknowledgement of debt, this IOU, was like a thing, a simple
thing lost in the world, but a thing already owed, already due, and I had
to keep it without taking it. To hold on to it as if holding it in trust, as
if on consignment, consigned to a photoengraved safekeeping. What
does this obligation, this first indebting, have to do with the verb of
this declaration that can never be appropriated, "we *owe* [devons] our-
selves to death?" What does the obligation have to do with what the
declaration seemed to mean? Not "we owe ourselves to the death," not
"we owe ourselves death," but "we owe ourselves *to* death."

But just who is death? (Where is it—or she—to be found? One says,
curiously, in French, *trouver la mort*, to "find death," "to meet with
death"—and that means to die.)

Still II

But just who is death? The question can be posed at each and every step in this photographic journey through Athens, and not only in the cemeteries, in front of the amassed tombstones, the funeral steles, the columns and the crosses, the archaeological sites, the decapitated statues, the temples in ruins, the chapels, the antique dealers in a flea market, the displays of dead animals—meat and fish—on a market street. The person who took his time to take these images of Athens over a period of almost fifteen years did not just devote himself to a photographic *review* of certain sites that *already* constituted hypomnesic ruins, so many monumental signs of death (the Acropolis, the Agora, the Kerameikos Cemetery, the Tower of the Winds, the Theater of Dionysus). He also saw *disappear*, as time passed, places he photographed, so to speak, "living," which are now "gone," "departed" [*disparus*], this sort of flea market on Adrianou Street, for example, or the Neon Café in Omonia Square, most of the street organs, and so on. This world that was the Athens of yesterday—already a certain modernity of the city— everyday Athens photographed in its everydayness, is the Athens that is now no longer in Athens. Her soul would risk being even less present, it might be said, than the archeological vestiges of ancient Athens. Their ruin, the only telling archive for this Market, this Café, this Street Organ, the best memory of this culture, would be photographs. We would thus have to meditate upon this invasion of photography into the history of the city. An absolute mutation, though one prepared from time immemorial (*physis, phōs, hēlios, tekhnē, epistēmē, philosophia*). This book thus bears the signature of someone keeping vigil and bearing more than one mourning, a witness who is doubly surviving, a lover tenderly taken by a city that has died more than once, in many times, a city busy watching over all that is noncontemporaneous within it, but a living city nonetheless. Tomorrow, living Athens will be seen keeping and keeping an eye on, guarding and regarding, reflecting and reflecting on its deaths.

Still III

We owe ourselves to death. I had in any case to pay my debt toward this sentence. No matter the cost. It had taken me, taken me by surprise (as if it had photographed me without my knowledge, unexpectedly, *exaiphnēs*); it had overtaken me, outstripped me, perhaps like death, a death that would have found me where I was still hiding; it had entrusted me with I don't know what for safekeeping, perhaps myself, and perhaps us; it had especially entrusted itself to me by making advances on me, by giving me an advance. It had granted me an advance. An advance, that's what it was, whatever else it might have been, wherever it might have come from and whatever it might have meant. In the eyes of this advance, I was not only the debtor but I was *late*. Given notice [*mis en demeure*] to pay restitution. I couldn't lose any more time; my first obligation was to save the sentence as soon as possible, without any further delay. This urgent sentence, moreover, suggested something about urgency. It insinuated at least, on the brink of urgency—leaving me free or pressing me without pressuring me—a law of imminence. Whence the idea, the first idea, my original impulse, of inscribing it in stone, right here, right away, the idea of fixing it or focusing on it precisely like an idea, *eidos* or *idea*, a form, a figure, in this element of eternity that our imagination naively associates with Greece and its petroglyphs. I would thus be able to settle up with it and then settle on leaving it, leaving it without losing it. This was precisely my desire, or else the opposite: to distance myself from it, to set out from it without ever leaving it.

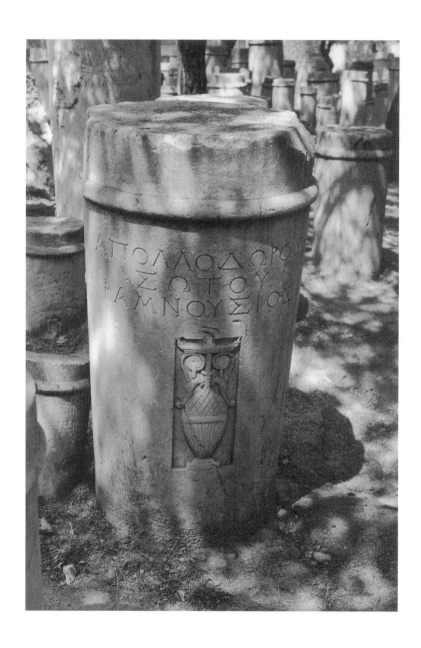

Still IV

I was taking a plane a few hours later, and I was having a hard time separating myself from everything, and especially from it, and so I began to dream of a camera equipped with a "delay mechanism": after setting up the camera, after adjusting the time of the pose and activating the "triggering device," I might be able, I said to myself, to run over to the side of those words—words loaned, not given—so that the snapshot might gather us all together once and for all. I would thus let myself be taken by surprise for a time without end, a time in proximity to which I would feel more finite than ever, myself now entrusted or consigned in turn to this sentence of stone, consigned for life and up until death [à la vie à la mort], linked thus to what would never be mine, but linked to it à demeure, that is, permanently, for the duration.

Still V

À demeure, he says. There is nothing here that is not already lodged, that is, à demeure, in the French demeure, from the house to the temple, along with everything that happens to be [se trouve] photographed here, right up to la dernière demeure, the final resting place: everything can be found here, from the injunction (demeure! stay!) to the mise en demeure. (We are mis en demeure, we are given notice, to pay what we owe within a certain time period, for example, to death, at death, to settle our accounts, in the end to be released from our obligations, and to do so without delay!.) Everything having to do with debt and delay can thus already be found in the word demeure, as in the sentence "we owe ourselves to death," everything, eternally, having to do with obligation and time, everything and the rest—remains, destiny, deferral, delay (demorari: to remain, to stop, to take one's time or to delay—which strangely resembles demori: to die, to waste away). But the syntax remains untranslatable, and I was not yet done with everything it keeps

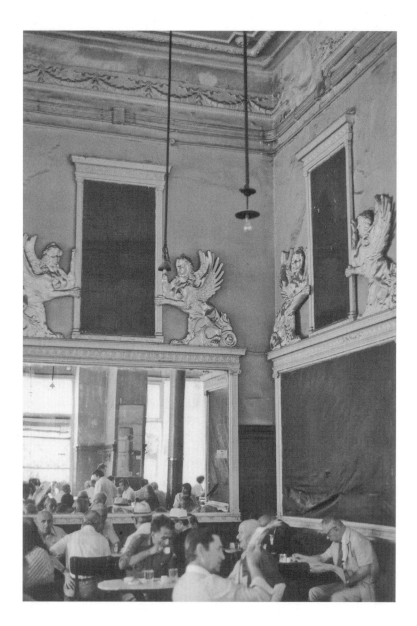

in reserve. I had the impression that, by focusing on these words like a photograph, one could—and the analysis would be endless—discover within them so many "things" that their letters showed by concealing themselves, remaining [*demeurant*] immobile, impassive, exposed, too obvious, although suspended in broad daylight in some dark room, some *camera obscura*, of the French language.

Still VI

For I had already sensed, through these photographs, a patient meditation, one that would take its time along the way, giving itself the time for a slow and leisurely stroll through Athens (fifteen years!), the pace of a meditation on being and time, being-and-time in its Greek tradition, to be sure, from the exergue from the *Sophist* that opens *Being and Time*. But being and time in the age of photography. Had not many trips to Greece over these past few years prepared me for this feeling? (There was, first of all, Athens (three times in fact), and Mykonos and Rhodes (where I had the impression of swimming for the very first time), and then Ephesus and Patmos, with George and Myrto, and then the Kaisariani Monastery with Catherine Velissaris and Demonsthenes Agrafiotis, following the footsteps of Heidegger, who, near the very same Greek Orthodox temple, did not fail to indict yet again in his *Aufenthalte* not only Rome, along with its Church, its law, its state, and its theology, but technology, machines, tourism, tourist attractions— and above all photography, the "operating of cameras and video cameras," which, in organized tours, "replaces" the authentic experience of the stay or the sojourn.)

We owe ourselves to death, we owe ourselves to death, we owe ourselves to death, we owe ourselves to death: the sentence kept on repeating itself in my head, so full of sun, but without reproducing itself.

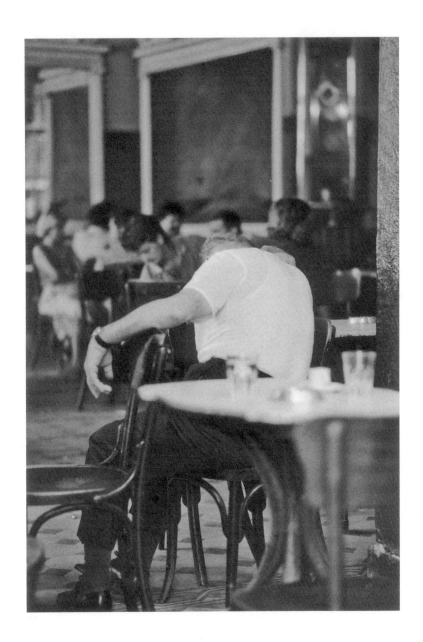

It produced itself each time for the first time, the same, to be sure, but each time anew completely new, like an original—or a negative without origin. Once and for all, the thing itself was lacking in this original negative.

It's now time; let us begin to look. Look at the *Photographer on the Acropolis* (no. 9), whom you can see meditating or sleeping, his head resting on his chest, in the middle of the book. I wonder if he hasn't set up in front of him, in front of you, an archaic figure of this delay mechanism. In order to photograph the photograph and its photographer, in order to let everything that has to do with photography be seen, in order to bookmark everything in this book. What exactly would he have done, the author-photographer of this book, the author, therefore, of this self-portrait? He would have set the animal-machine up on a Delphic tripod. In following here the echo of my fantasy, everything would thus be suspended in the interval of this delay, a sort of diaphanous time in an air of invisibility. His eyes are closed, but the photographer protects them further from the light with sunglasses. The author of a photograph would have also looked for, indeed even sought out, the shade of a parasol, unless it happens to be a reflector.

Still VII

We owe ourselves to death. This sentence was right away, as we have come to understand, greater than the instant, whence the desire to photograph it without delay in the noonday sun. Without letting any more time pass, but for a later time. Why this time delay? An untranslatable sentence (and I was sure, from the very first instant, that the economy of this sentence belonged to my idiom alone, or rather, to the domesticity of my old love affair with this stranger whom I call my French language), a sentence that resists translation, as if one could

only photograph it, as if one instantaneously had to take its image by surprise at its birth: immobile, monumental, impassive, singular, abstract, in retreat from all treatment, unreachable in the end by any periphrasis, by any transfer, by rhetoric itself, by the eloquence of transposition. Reticent like a word that knows how to keep silent in order to say so much, a word frozen in its tracks [*tombée en arrêt*], or pretending, rather, to be freeze-framed [*arrêt sur image*] before a video camera. An oracle of silence. It gives itself in refusing itself. One time for all times. As soon as it *takes* [prend] in language (but who will translate this *prendre* in the phrase "dès qu'elle *prend* dans la langue"), and once it is taken by it, it resembles a photograph. The sentence takes in photography, or takes a photograph of the language that photographs it (like the photographer who photographs himself when he takes a photograph of himself in this book). They are taken, the one and the other, in the unique example of this apparition, this sentence here and not another, in this irreplaceable language; it is thus, it was thus, it happened, it took place, this sentence here, one time for all times, as "we owe ourselves to death."

Still VIII

Prendre une photographie, to take a photograph, *prendre en photographie*, to take a photograph but also to take in photography: is this translatable? At what moment does a photograph come to be *taken*? And taken by whom? I am perhaps in the process, with my words, of making off with his photographs, of taking from him the photographs that he once took. Can one appropriate another's mourning? And if a photograph is taken as one takes on mourning [*prend le deuil*], that is, in separation, how would such a theft be possible? But then also, how could such a theft be avoided?

Still IX

I was coming back that day with friends from Brauron to Athens. It was around noon, and we were on our way to go swimming, after having paid our respects to the young girls walking in a procession toward the altar of Artemis. The day before I had already returned, yet again to Athens, but that time it was from the tip of Cape Sounion, where we also went swimming, and I had recalled at the time the other signature of Byron, the other petroglyph marking his passage—at Lerici this time, near Porto Venere. And I recalled the time it took for Socrates to die after the verdict condemning him (and the name *Sounion*, as we know, is inseparable from this). This was my third stay in Greece. Barely stays, regrettably, more like visits, multiple, fleeting, and all too late. Why so late? Why did I wait so long to go there, to give myself over to Greece? So late in life?

But a delay, these days, is something I always love as what gives me the most to think, more than the present moment, more than the future and more than eternity, a delay *before* time itself. To think the *at-present* of the now (present, past, or to come), to rethink instantaneity on the basis of the delay and not the other way around. But delay is not exactly the right word here, for a delay does not exist, strictly speaking. It is something that will never be, never a subject or an object. What I would rather cultivate would be a *permanently delayed action* [retardement à demeure], the chrono-dissymmetrical process of the moratorium [*moratoire*], the delay that carves out its calculations in the incalculable.

Still X

I have always associated such delayed action [*retardement*] with the experience *of* the photographer. Not with photography but with the photographic experience of an "image hunter." *Before* the snapshot or

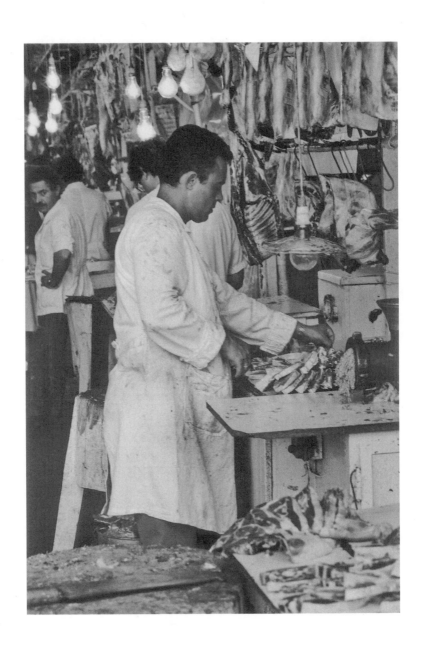

instamatic [*instantané*] that, from the lens or objective, freezes for near eternity what is naively called an image, there would thus be this *delayed action*. And thoughtful meditation on this delayed action always gets woven within me along the lines of two Athenian threads: *photography* (the writing of light—is there a word more Greek?) and the enigmatic thought of the *aiōn* (the interval full with duration [*l'intervalle plein d'une durée*], an incessant space of time, and this is sometimes called eternity). The *intriguing* possibility of a delayed action gets woven or plotted out in advance along the lines of these threads. Incessantly.

Incessantly [*incessamment*], what a word.[3]

Whence my passion for delay, and for the delay within delay (a periphrasis for the advance, since time is needed to make this move), and my mad love for all the figures of this moratorium *en abyme* that are organized within photographic invention—and with almost the sole aim of illustrating or bringing such invention to light—by the technique that goes by the name of the delay mechanism, the automatic timer, or the automatic shutter release [*dispositif-retard, déclenchement-retard, le retard automatique*]. At once banal in its possibility and singular and unprecedented in its operational workings, it has given rise today to mechanisms that are so much more sophisticated than so many imaginable sophistics. Everything is going to be in place in just a moment, at any moment now [*incessamment*], presently or at present, so that, later, a few moments from now, sometimes a lot later or even a very long time from now, another present to come will be taken by surprise by the click and will be forever fixed, reproducible, archivable, saved or lost for this present time. One does not yet know what the image will give or show, but the interval must be objectively *calculable*, a certain technology is required, and this is perhaps the origin or the essence of technology.

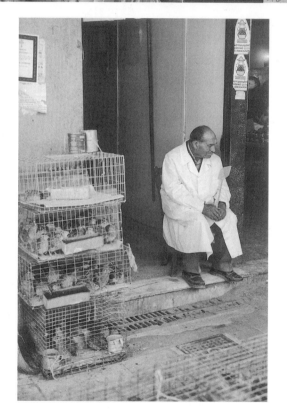

Still XI

Let's go back to the *Photographer on the Acropolis*, whom you can see meditating or sleeping, his head slouched down, in the middle of this book. Has he not set up in front of him, in front of you, an archaic figure of this delay mechanism? Did he not decide, after some reflection, to photograph photography and its photographer, in order to let everything that has to do with photography be seen, in order to bookmark everything in this book? He would have set the animal-machine on a Delphic tripod. His eyes are closed, as you can see, and he protects them even further from the light with sunglasses; he even sought out the shade of a parasol—unless it's a reflector.

As in an antique store, make an inventory of everything you can count up around this *Photographer on the Acropolis*. Configured on the scene or stage of a single image, accumulated in the studied disorder of a prearranged taxonomy, there's an example, a representative, a sample of all visible *aspects*, of all the *species*, *idols*, *icons*, or *simulacra* of possible things, of *"ideas,"* if you will, of all those shown in this book: within a space where all times *intersect* or *cross paths* (an archaeology of ruins, a cemetery of phantoms, authentic antiquities or the merchandise of antique dealers, a conservatory of Athenians, both living and dead, a market or resale store in a street of yesteryear, and so on), there is also a *crossing* of all the kingdoms of the world (*crossing* in the sense of genealogy and genres, but also in the sense of fortuitous encounters, of this *tukhē* that gathers them all together along the way, there where they just happen to be, as it just may happen in a photograph that perhaps feigns improvisation), all the *kingdoms* whose sediments this book analyzes: (1) everywhere you look, the petroglyphs of a *mineral* memory; (2) the *vegetation*, rare but visible, growing between the stones; (3) an archeology fixed in stone of the Athenian *divinities* (the allusions of the book suggest Dionysus rather than Apollo); (4) the living *animal*,

· 9 ·

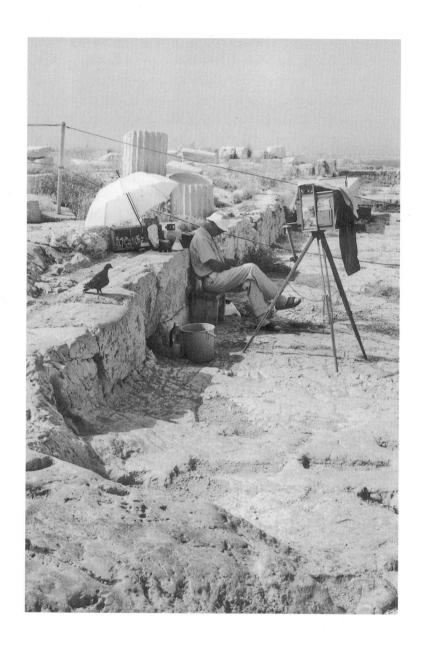

the photozoography of a black pigeon on the left (are its feathers black or are they just in the shadow of this skiagraphy?); (5) the living *human*, the photographer himself or his model, the one *as* the other, the one producing or *re*-producing the other, the one as the generator or the progenitor of the other; (6) *technical* objects, whether (a) everyday implements (the bench, the bucket next to a fountain, if I'm seeing it right) or (b) machine-instruments (two cameras, at least, from two generations, one large one small, one old one young, one more archaic than the other, an archeology of photography; (7) and then so many *abyssal* or *reflecting screens* (the cameras themselves, the sunglasses, the parasol-reflector); $(8 + n)$ and, finally, the representations displayed on the camera itself and under the parasol. These representations, these photographs of photographs (these *phantasmata*, as Plato would have hastened to say, and that is why one can no longer count here, no longer count on this process of reflection, for as soon as you count on it you can no longer count, you lose your head or you lose the *logos*), these copies of copies that you can see in two places, at once *in front of* the photographer, on the body of the camera set on the tripod, and *behind*, behind the back of the photographer, under the parasol— these are perhaps some of the photographs of the book. The book announces itself in this way.

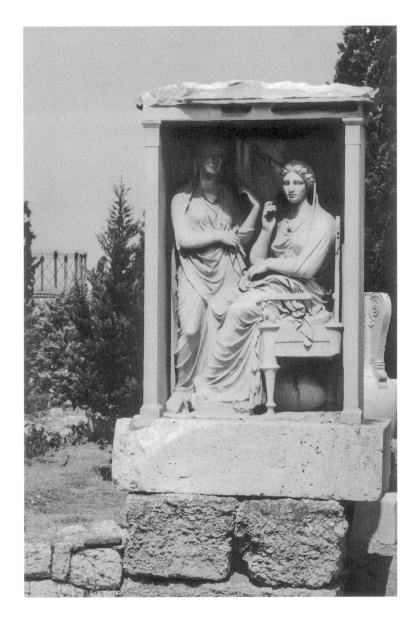

Still XII

When, exactly, does a shot [*prise de vue*] take place? When, exactly, is it taken? And thus where? Given the workings of a delay mechanism, given the "time lag" or "time difference," if I can put it this way, is the photograph *taken* when the photographer takes the thing in view and focuses on it, when he adjusts the diaphragm and sets the timing mechanism, or else when the click signals the capture and the impression? Or later still, at the moment of development? And should we give in to the vertigo of this metonymy and this infinite mirroring when they draw us into the folds of an endless reflexivity? Does not one of the other photographs, *The Parthenon* (no. 11), exhibit, at least in part, the *same* camera on a tripod, the *same* parasol or the *same* reflector? Does not the same camera also display photographs on its side? Other photographs this time, it is true, the portrait of a man and, in addition (a supplementary *mise en abyme*), reduced-size images of this very Parthenon, which forms the background for everything else? My hypothesis is that this structure is generalized throughout the book. It is its law, and it will even have engendered this so cleverly calculated book, engendered it through a nonspontaneous generalization. Whence the putting to the test and the program that I would be able to sketch out later: incessantly to walk along this line of the abyss, to try to look without trembling at this infinite mirroring that carries the reflection of all these photographs, to take up the list of the 8 + n categories or "genres of being" and play at sorting each of these shots into ontological boxes or squares, hopscotching, as it were, from one to the next. Like cards on a map, a sort of Cartesian cartography. But I know in advance that metonymy will make this classification impossible and lacking in rigor. Exposed to repetition, each take—each shot [*cliché*]—will have more than one place in this classificatory schema. But it doesn't matter; I will try this another time, if only to do or to prove the impossible.

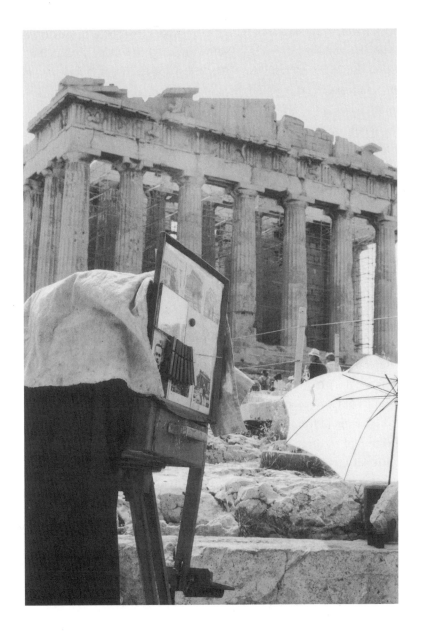

Still XIII

Imagine him, yes him, through the images he has "taken." Walking along the edge, as I said just a moment ago, of the abyss of his images, I am retracing the footsteps of the photographer. He bears *in advance* the mourning for Athens, for a city owed to death, a city due for death, and two or three times rather than one, according to different temporalities: mourning for an ancient, archeological, or mythological Athens, to be sure, mourning for an Athens that is gone and that shows the body of its ruins; but also mourning for an Athens that he knows, as he is photographing it, in the present of his snapshots, will be gone or will disappear tomorrow, an Athens that is already condemned to pass away and whose witnesses (*Adrianou Street Market* [no. 20], the Neon Café on Omonia Square [no. 2], *Street Organ* [no. 4]) have, indeed, disappeared since the "shot" was taken; and finally, the third anticipated mourning, he knows that other photographs have captured sights that, though still visible today, at the present time, at the time this book appears (*Athinas—Meat Market* [no. 6] and *Fish Market* [no. 13]), *will have* [devront] to be destroyed tomorrow. A question of debt or of necessity, a question of economy, of the "market," all the sights along these streets, all these cafés, these markets, these musical instruments, *will have* [devront] to die. That is the law. They are threatened with death or promised to death. Three deaths, three instances, three temporalities of death in the eyes of photography—or if you prefer, since photography makes appear in the light of the *phainesthai*, three "presences" of disappearance, three phenomena of the being that has "disappeared" or is "gone": the first *before* the shot, the second *since* the shot was taken, and the last later still, for another day, though it is imminent, *after* the appearance of the print. But if the imminence of what is thus due for death suspends the coming due, as the *epoch* of every photograph does, it signs at the same time the verdict. It confirms and seals its ineluctable authority: this will have to die, the *mise en demeure* is underway,

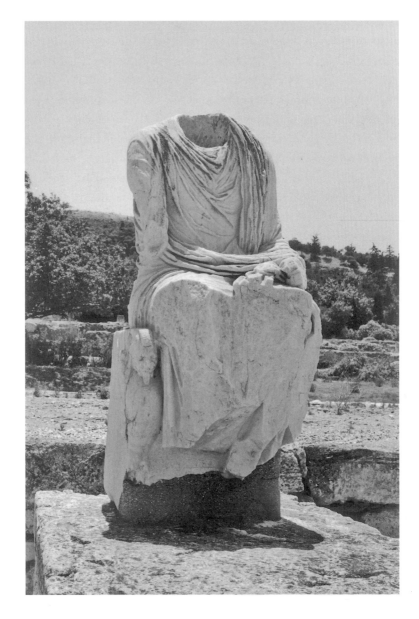

notification has been given, the countdown has already started, there is only a delay, the time to photograph, though when it comes to death no one even dreams of escaping it—or dreams that anything will be spared. I am thinking of the death of Socrates, of the *Phaedo* and the *Crito*. Of the incredible reprieve that delayed the date of execution for so many days after the judgment. They awaited the sails, their appearance off in the distance, in the light, at a precise, unique, and inevitable moment—fatal like a click.

Still XIV

We know what Cape Sounion meant for the death of Socrates. It is from there, in short, that Athens saw it coming—his death, that is. By ship. From the temple of Poseidon, at the tip of the cape, during my first visit (it was the day before the sentence "we owe ourselves to death"), I imagined a photograph, and I saw it before me. It eternalized, in a snapshot, the time of this extraordinary moment: Socrates awaiting death. That he was told about the passing of the sails so close to Athens, just off the cape, off this very cape and not another, from the heights of this very promontory where I found myself with friends before going swimming down below, at the foot of the temple, that this was the same cape, impassive, immutable, silent like a photograph—that is what will continue to amaze me to my dying day. All of this belongs to the luminous memory of Athens, to its phenomenal archive, and that is why I dare insist upon it here. I would thus have photographed Socrates awaiting death, Socrates knowingly awaiting a death that had been promised him: while others are on the lookout at Cape Sounion, he knowingly awaits during the entire time of this delay. But he decided not to escape; he knows that this will be but a temporary reprieve, this delay between the speaking of the verdict and the taste of the *pharmakon* in his own mouth. He

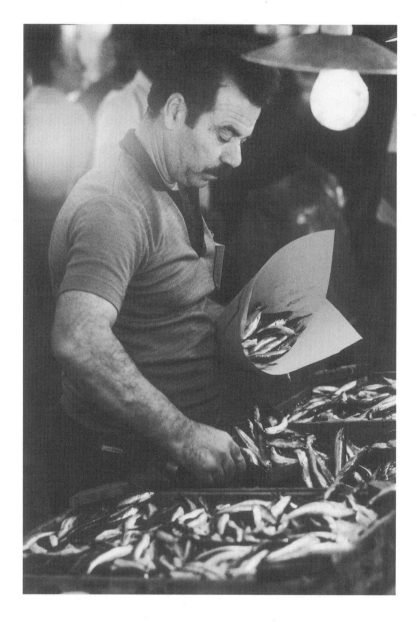

prepares himself for it and yet he speaks to his friends about preparing for death, about the exercise, care, or practice of death (*epimeleia tou thanatou*), a discourse that still watches over us, a discourse of mourning and of the denial of mourning, all of philosophy. This discourse entertains irresistible analogies to, but has absolutely nothing to do with, I am certain, the verdict "we owe ourselves to death"—a sentence that might even say the contrary and will always remain, moreover, something that belongs to the French idiom. Yes, we still share the same wonder (*ethaumazomen*) expressed by Echecrates. He is the one who asks Phaedo what *happened*. What, exactly, *took place*? While the verdict had been pronounced long before (*palai*), the death had been put off until "much later" (*pollōi hysteron phainetai apothavōn*). To answer the question of what happened (*Ti oun ēn touto, ō Phaidōn*), Phaedo invokes chance, *tukhē* (it happened in this way because it just so happened that way); it was "a matter of chance." "It happened that the stern of the ship which the Athenians send to Delos was crowned on the day before the trial." What ship? The one, following an ancient Athenian tradition (we are still recounting the history of Athens), that once carried the *seven boys and seven girls* whom Theseus led to Crete and whom he then saved in saving his own skin. It is, in short, this saving, and the pledge that followed, that is responsible for granting Socrates a reprieve of a few days, a provisional salvation, in this case, the time for an unforgettable discourse on true salvation, salvation by philosophy. Because in order to give thanks for the safe-conduct of the young boys and girls led by Theseus, the Athenians had made a pledge—a pledge to Apollo. They pledged to organize a yearly pilgrimage or "procession" (*theōria*) to Delos. The law (*nomos*) of Athens thus prescribes that during the entire time of the *theōria* "the city must be pure and no one may be publicly executed until the ship has gone to Delos and back" (*Phaedo* 58b). This time is not calculable, and neither is the delay, therefore, because

the voyage took a long time and the winds were sometimes, unforesee-ably, unfavorable. Such an uncontrollable delay mechanism (what is called *physis*), such incalculability, grants Socrates an indeterminable reprieve. One knows when the *theōria* begins, but one does not see the end. One can determine the *arkhē tēs theōrias*, the moment when the priest of Apollo crowns the stern of the ship, but one never knows when the *theōria* will end, and when a sail will announce the return from off Cape Sounion. That is the interval that separates the verdict from the death; that is the delay that stands *between* these two moments. That is why, Phaedo concludes, "Socrates passed a long time [*polus khronos*] in prison between his trial and his death [*metaxu tēs dikēs te kai tou thanatou*]" (*Phaedo* 58c). One never knows when the *theōria* will end. And yet—a story of the eye—Socrates claimed to know it; he claimed to know when the *theōria* would end thanks to a dream or, more precisely, by means of a knowledge [*savoir*] based on a *seeing* [voir], the seeing of a *vision* (*enupnion*) come to visit him in the middle of the night in the course of a dream. A dream in black and white that was awaiting us. It will await us even longer. It is right at this moment of presumption that I dreamed of photographing him, photographing Socrates as he speaks and claims to have foreseen the instant of his death. When he claims, by a kind of knowledge, an unconscious knowledge, it is true, to see in advance, to foresee and no longer let himself be taken by surprise by the delay of death. My own dream telesympathized with his. It was in accord with what he says about it.

Still XV

Meeting with a *Photographer on the Acropolis*. He seems to be sleeping, dreaming perhaps, unless he has died, struck down right there by a sun stroke, his head slouched down on his chest. He is perhaps the author of this book. He would have photographed himself, in full sunlight. Here, then, is the heliograph: he wears a hat on his head, but he is still too exposed because the parasol or the reflector behind him is no longer over his head, protecting, it would seem, only other photographic images, already a few reproductions, no doubt. You can make out another camera, much smaller, behind him. And in front of him, on a Delphic tripod, a camera from another age is looking at him, unless it is looking elsewhere, perhaps equipped with a delay mechanism. The autophotographer has laid out around him, as if he had saved them on his ark, an example or copy of every species of thing, not each of the genres of being distinguished in Plato's *Sophist* (being, movement and rest, the same and the other), not each of the ontological regions of transcendental phenomenology, not the categories or *existentials* of *Being and Time* (*Dasein, Vorhandensein, Zuhandensein*), but 8 + n "other things." He thought he had thus divided up *physis* or the *kosmos*, the world and then the world of culture within it, if you want to hold onto these later categories, the world or its photographic archive: in 8 + n kinds of "things." He dreamed that all these photographs would take these things by surprise, in order or out of order, at random, there where they *happened to be found*. He inspected and inventoried them.

1. The *mineral* and earthen thing, materiality without life, whether ruins or not, whether with or without inscription: *all* these photos belong in some way to this first class.

2. The *vegetal*, growing thing: almost all the photos (the only exceptions to this form of *physis*, to this more or less "natural" form of growth, are a few images of the market or the café, a few fragments

of frescoes, Zeus seated in the frieze from the Theater of Dionysus, a detail of a funeral stele, the throne of the priest of Dionysus, and the bouzouki player: everywhere else, something is *growing*).

3. The *divine* thing (nearly all the statues and the steles, all the temples, a good half the images).

4. The *animal* thing. But here things get a bit too complicated, for there is the subclass of *living beings* (the pigeon *outside*, near the photographer, for example, and the dog *inside*, just as black, near the sculpture in the *Stoa of Attalos* [no. 29]) and then the subclass of the *dead* (of those put to death in truth, killed *en masse*, but less "natural," already "merchandise" or "commodities" in the meat or fish market, in the hands of merchants); and then there are the living beings roaming *freely* (whether "*natural*," the pigeon, or "*domesticated*," the dog) and living beings *in captivity* (this other kind of merchandise in the form of baby chicks in cages in the Athinas Market [no. 8]). The dream runs out of steam, but the dreamer goes on. As does his taxonomy. We are only about halfway there. One is reminded of all the classifications of the *Sophist* (one would be tempted to try them all out, but this has to be given up), all those we encounter even before getting to the mimetic arts, notably, the photographer as fisherman or angler, an image hunter whose art is unclassifiable because it partakes simultaneously, being neither a mimetics nor a sophistics, of all the categories set in opposition to one another by the Stranger: "poetic" or productive arts as opposed to acquisitive arts, acquisition through exchange as opposed to by coercion, coercion by fighting as opposed to hunting, hunting inanimate things as opposed to living things, living things or animals that walk on land as opposed to those that swim, animals that "swim" through the air as opposed to those that swim in water (219c–220b). The image hunter has all of this in his book, but who would be able to decide whether his is an art of production or reproduction? Just

try to adapt all the Platonic categories here, for example, the "mimetic" and the "phantasmatic," just give it a try, and have a field day!

5. The *human* thing (the thing with a *human face*, subcategories: *artists*, a photographer and the specter of an absent painter, *merchants and passersby*, and then *merchants of art or of pastimes*, like the organ-grinder).

6. The *technical* thing (a human thing as well, but this time *without a face*) seems to defy classification even more. Why? Beyond the difficult distinction between tool and machine, between everyday implements (chairs and glasses in *A Few Moments in the Neon Café* [no. 3], the little bench of *Photographer on the Acropolis* [no. 9], the scales of the Athinas Market [no. 22], the bouzouki of *Bouzouki Player* [no. 23]) and machine-tools (the street organ, radios, telephones, the fan, the cameras themselves), one has to acknowledge that nothing is altogether natural in this world, everything is shot through with law, conventionality, technology (*nomos*, *thesis*, *tekhnē*). (These have in advance invaded *physis* and ruined its principle or its phantasm of purity. History as well, and that is enough to threaten, in the photographer's dream, this classification compulsion.) For the same photographer exercises an unprecedented art of composition in the service of his mourning. In the service not of a personal nostalgia but of a melancholy that marks a certain essence of historical experience or, if you prefer, the meaning or sense for history. For photography has a sense of history, but it also opposes an impassive and implacable sensibility, an insensible sensibility, to the historicity of what is still going or going well—or not going or not going so well, to what is no longer going well but goes nonetheless and, in going, goes away, remains in the process of going away, here for fifteen years, the fifteen years during which the photographer paraded his meditation through Athens, camera in hand, curious about everything. Multiplying the spectacles of ruins, and of ruins of modern

times, someone thus went out of his way to recall the emblem of such ruins in these images of a flea market, whose studied order exposes so many "technical" or "cultural" objects that have in common their being defunct (*defunctus*), that is, without function, obsolete, out of commission, dysfunctional, fallen into disuse [*désaffecté*]. The tool and the machine are stripped down to being mere "things." But the thing is also a fetish, a *disused* object, *divested* of use but then *reinvested* with the surplus value of a fetish, a fetish to keep an eye on, to keep, to sell, to see being sold. An original affect, an affect without pathos, surrounds the aura of these photographs: the sense of obsolescence [*l'affect de la désaffection*], precisely, the affect of the one affected by this disuse or obsolescence of technical objects, defunct signs of culture. Is not this affection of the photographer for these implements or signs fallen into disuse also an affect of the delay, of the delay without return? Without return, and that is why I hesitate to use the Greek word that you no doubt have on the tip of your tongue, the Greek word that speaks of the longing for return, of homesickness—*nostalgia*. If there is nostalgia in these photographs, nothing makes it obvious. But that is not all. Among these fetishes (and it will be incumbent upon us later to recall that the photograph of a fetish fetishizes in its turn its own abyss, for every photograph is a fetish), history, history as the historicity of technology, is seen to be discreetly but surely exposed, recounted, analyzed, "objectified" by the objective or the lens—precisely as the history of ruin or disuse, the history of obsolescence. Two or three examples: besides the measuring instruments (scales and weights), besides the recording or transmitting devices (radios, typewriters, tape recorders), besides the instruments of art and technology (music, painting, and photography), you will be able to confirm that, whether in use or out of use, the cameras belong to several different technological generations. Is this just a coincidence? It is at the very least the sign of a

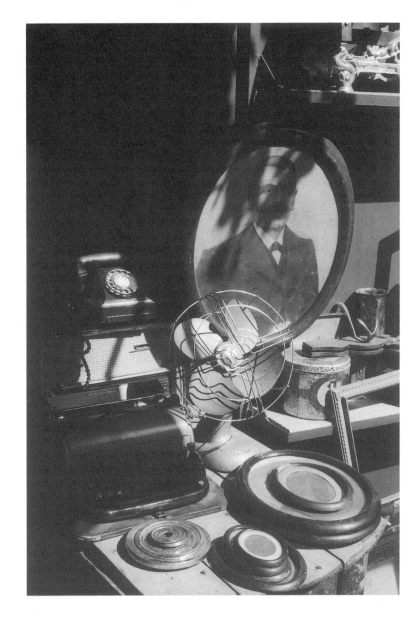

history of photographic technology—and, as always, of its ruin and its mourning, its archive and its fetishization. Then there are the musical instruments: they are not alone in recalling a history of sonography, just as the tape recorder recalls a history of phonography. Here is a telephonography (and Socrates' daimon enters momentarily into the dream of the photographer) that announces to you its program: there are at least *two old telephones* for sale (one has to wonder what was the last message to be interrupted at the moment of disconnecting these conveyers of voices), and the two telephones are both to be found in the *upper left*, in the displays of two different merchants, one at the Monastiraki Market (no. 19) and the other at the Adrianou Street Market (no. 20). Neither of them is working, true, but one looks like the ancestor of the other. (It is, moreover, right next to a photographed ancestor, a prominent Athenian, I imagine, with a full mustache in an oval frame, an effigy that the heirs wanted to get rid of for a little money, yet another way of mourning.) The ancestral telephone has a dial, the younger one is a touchtone. Black and white too *en abyme*: the old telephone is black with a white spot in the middle; the younger one is light, with a dark spot on its tummy. Each telephone is placed on top of an old radio. It's as if we were being reminded, in the middle of all these musical instruments, that these photographs bear the mourning of sounds and voices. Negatives of sonograms or of phonograms, multimedia in mourning, compact disks (CDS, video cassettes, or CD ROMS) all of a sudden voiceless—allowing us to hear all that much better the spectral echo of what they silence. The echo becomes in us the original. These photograms would resonate like echographic whispers; they would immediately emanate from out of memory. That is the photographer's touch, in the service of his gaze, of his reflection, of the light he projects or *reflects*. And sometimes it is an *artificial* light.

7. Under the heading of *reflection*, precisely, there would be even

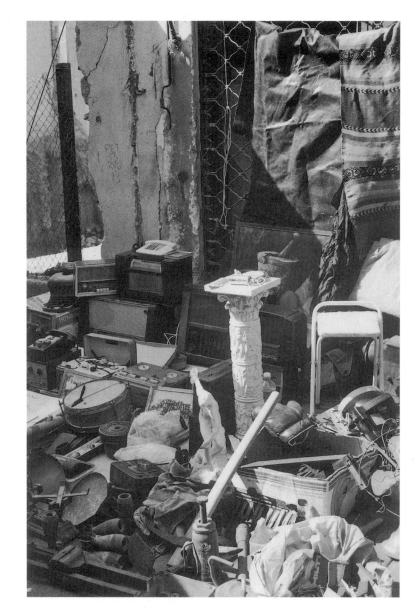

more to say: everything is reflected and reflected upon, of course, by both the photographer and the photographic process. But in addition, the "technological" art and artifice of reflection, such as those found in artificial lighting, turn out to be *represented* at every moment. Count, for example: (1) the numerous *light bulbs* above the displays of the meat market or the fish market (nos. 6 and 13), and then those in the Neon Café (no. 2), which hang down from the ceiling on a long wire (given all the discarded appliances or instruments exhibited here—radio, tape recorder, fan—this book fixes or focuses on a certain epoch of electric culture in modern domesticity, a short history of Athenian electricity, and everything seems to be calculated on the basis of this electrology, right up to that calculating thing that goes by the name of an electric meter, just to the left of the two brothers in the Athinas Market [no. 22]); (2) *parasol-reflectors*; (3) the *mirrors* in the Neon Café and behind the two brothers in the Athinas Market.

8. Reflections on reflection and the infinite mirroring of the *mise en abyme* (in the large sense of the term: the metonymic representation of a representation), reflections on the phantasms of simulacra or the simulacra of phantasms (to cite or to sidetrack Plato)—the innumerable, playful ways in which photography, or else painting, is photographed. Here again, between painting and photography there is a pseudo-difference of generations, as the art of one generation represents in its own fashion the art of an earlier generation. Just look at the easel on which there is a painting of ruins in perspective (*Near the Tower of the Winds*, no. 25): the painter is gone, the photographer remains invisible, and the woman spectator, seen from behind, seems at once to look on without understanding and to let herself be taken in by the spectacle. Even though, in a certain sense, everything is "representation" in what is photographed in this way, one can count the representations of representations, for example, certain photographs or paint-

ings that themselves become elements within the overall picture, such as those we have already mentioned, the portrait in the oval frame or the painting of ruins, the images in newspapers and magazines against the backdrop of a wall covered in graffiti in the Adrianou Street Market (no. 21), or else, in a narrower sense of the term, representations of representations *en abyme* (*The Parthenon—Photography in Waiting*, no. 11), where the Parthenon itself becomes the object of a photograph and where three or four copies of this photograph (more or less identical shots, it seems) are framed near a portrait and displayed on a camera, which is itself photographed with the Parthenon in the background. One can even make out, it seems, small human figures, "customers" probably, tourists in black and white, in the two generations of representations. Their respective places have changed—a sign of the passing of time. Like the painter earlier, the photographer is invisible, but he is nonetheless there, not far from the camera on the tripod, another camera this time, it too draped in black and white. In the very diversity of their structure (simulacra, phantasms, representations of representations, photos of photos, photos of painting or of images in general, infinite mirroring), these reflective processes hollow out, at once deepen and drain, the affect or sense of obsolescence we discussed earlier. They demonstrate an affection for what has fallen into disuse, a mourning that keeps within itself what it loses in the keeping. An acknowledgement of a debt or an IOU with regard to death is signed by everything that *reflects* in the photographic *act* as well as in the structure of the photogram. And this is the case no matter what is represented, no matter the theme, content, or object of the image, even when death is not shown therein, not even indirectly recalled or figured. The debt does not wait for the funeral stele or the inscription on a sepulture. The most living thing can let the debt be *heard*, as soon as it is taken in photography, the baby chick in its cage or the bouzouki player. And even if

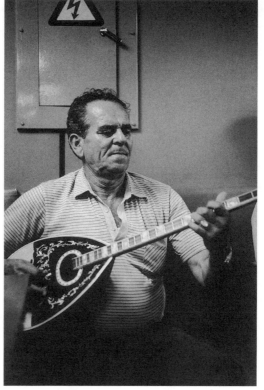

all these musical instruments, radios, telephones, and tape recorders did not recall it, the phonogram of this music of death would resonate here in black and white, from one photo to the next. Like a silent song. Like a dirge of mourning that recalls, for example, Demeter weeping for Persephone, who had been abducted by Hades and whom Theseus, yes, him again, tried to carry away by descending into the underworld. At the center of one of the photographs, a spectacular street sign, the only one, commemorates Korē, the young girl: ΟΔΟΣ ΠΕΡΣΕΦΟΝΗΣ, just above its transliteration, PERSEFONIS (no. 24). Does not Persephone reign over this entire book, Persephone, wife of Hades, the goddess of death and of phantoms, of souls wandering in search of their memory? But also (and this is another world of significations with which the figure of Persephone is associated) a goddess of the image, of water and of tears, at once transparent and reflecting, mirror and pupil? Korē, Persephone's other name, means both young girl and the pupil of the eye, "what is called the pupil [korēn kaloumen)," and in which, as Plato's *Alcibiades I* reminds us, our face is reflected, in its image, in its "idol," when it looks at itself in the eyes of another. One must thus look at this divinity, the best mirror of human things (133c). And all that would be due to death, along with the specters, and the photographic pupil, and the symphony of all these musical instruments.

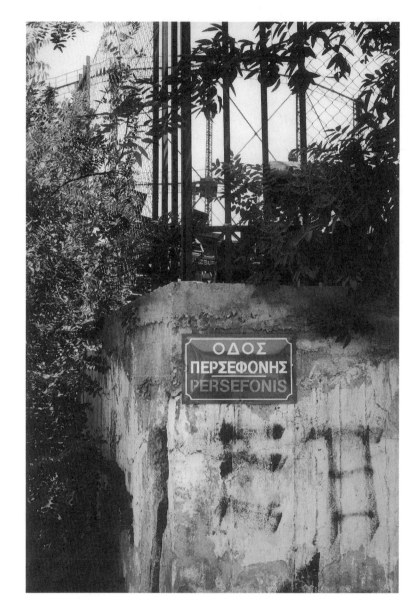

Still XVI

To photograph Socrates as a musical instrument. And musical instruments as so many Socrateses. For what does Socrates do? He waits, but without waiting; he awaits death and dreams of annulling its delay by composing a sacrificial hymn. Death is indeed slow in coming, but he knows, he believes he knows, how to calculate the arrival of the day of reckoning. Not that he *sees it coming*, sees death coming, from Cape Sounion, no, he *lets* it come, he *hears* it coming, you will recall, and this too is a kind of music. He dreams, he dreams a lot, Socrates does, and he interprets his dreams. He describes them and wants to comply with what they prescribe. He wants to do what he has to and he knows what he has to do, what he owes. One of these dreams announces death to him; it tells him *when* death will come, when the delay will end, along with its imminence. The other enjoins him to pay a debt by composing music to offer to the god whose votive festival was responsible for deferring his death. In the *Crito*, as we know, Socrates owes to a dream the power to calculate the moment of his death. The dream of a night allows him to see and to hear. Apparition and appellation: tall and beautiful, clothed in white, a woman calls him by name in order to give him this rendez-vous, the moment of death, thus annulling in advance both the delay and the contretemps. (Is this not the very desire of philosophy, the destruction of the delay, as will soon be confirmed?) She comes to him, this woman does, as beautiful, perhaps, as the name of Socrates; he "thought he saw" her coming, thus seeing the death that would not be long in coming. One has the feeling that his own name has all of a sudden become inseparable from the beauty of this woman. Neither this beauty nor his name, as a result, can be separated from the news of his death: news announcing to him not that he will die, but rather that he will die at a particular moment and not another. The woman predicts for him not a departure but an arrival. More precisely, she orients the departure—for it is indeed necessary to depart and part ways,

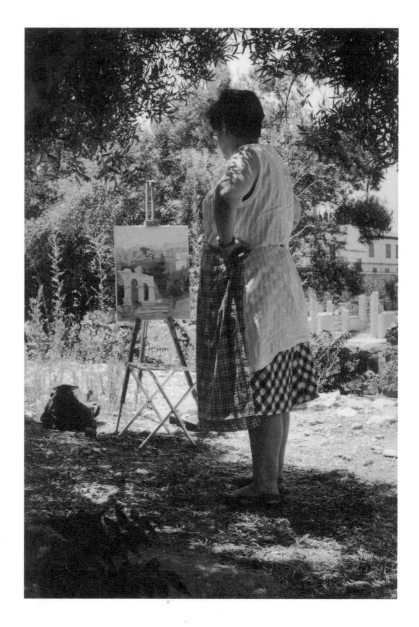

to leave and take one's leave—from the voyage's point of *arrival* by citing the *Iliad*. But Crito persists in deeming this dream to be extravagant, strange, or mad (*atopon to enupnion*), and he continues to dream of Socrates' "salvation."

SOCRATES: What is this news? Has the ship come from Delos, at the arrival of which I am to die?

CRITO: It has not exactly come, but I think it will come today from the reports of some men who have come from Sounion and left it there. Now it is clear from what they say that it will come today, and so tomorrow, Socrates, your life must end.

SOCRATES: Well, Crito, good luck be with us! If this is the will of the gods, so be it. However, I do not think it will come today.

CRITO: What is your reason for not thinking so?

SOCRATES: I will tell you. I must die on the day after the ship comes in, must I not?

CRITO: So those say who have charge of these matters.

SOCRATES: Well, I think it will not come in today, but tomorrow. And my reason for this is a dream which I had a little while ago in the course of this night. And perhaps you let me sleep just at the right time.

CRITO: What was the dream?

SOCRATES: I thought I saw a beautiful, fair woman, clothed in white raiment, who came to me and called me and said, "Socrates, on the third day thou wouldst come to fertile Phthia."[4]

A little later, so to speak, on the next day (this is in the *Phaedo*, "the day before, when we left the prison in the evening we heard that the

ship had arrived from Delos"[5]), a dream again dictates the law. Unlike the other dream, this one does not give Socrates anything to see or to hear; it gives an order, it "prescribes" or orders him to compose and devote a hymn to the god who, while giving him death, thereby grants him the time of death, the delay or the reprieve as well as that which puts an end to the reprieve, the delay that does away with itself. Socrates owes him this temporary stay of execution, and he is beholden to this stay. And this music, "the greatest music," is philosophy. Socrates must thus transform himself into a musical instrument in the service of this philosophical music. He has just recalled that the same dream (*to auto enupnion*) has visited him regularly throughout the course of his life. The vision was not always the same, neither the image nor the "phenomenon" of what "appears to the eyes"—the photograph, if you will—but the words always said the same thing (*ta auta de legon*): "'Socrates,' it said, 'make music and work at it.'" Socrates is certain that that's what he has always done:

Because philosophy was the greatest kind of music and I was working at that. But now, after the trial and while the festival of the god delayed my execution, I thought, in case the repeated dream really meant to tell me to make this which is ordinarily called music, I ought to do so and not to disobey. . . . So first I composed a hymn to the god whose festival it was.[6]

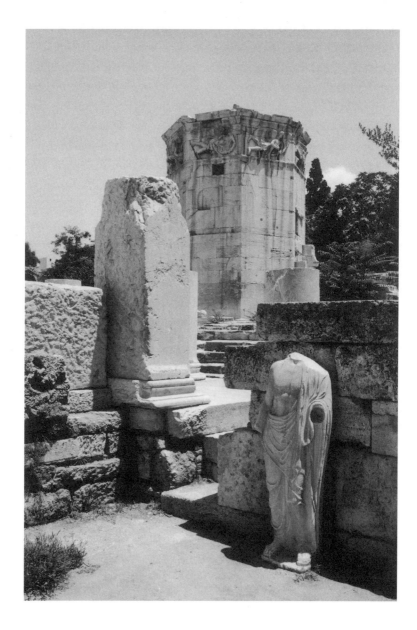

Still XVII

We owe ourselves to death. To commemorate the arrival of this sen-
tence into my language, I would have to dedicate centuries of books
to this memory. I immediately declared it to be untranslatable, turn-
ing to Myrto (who was behind me, to my left, beautiful like her name,
in the back of the car), to Georges, who was driving and laughing like
a demon—tender, sarcastic or sardonic, innocently perverse (more
or less perverse than he believes or would like others to believe, like
all self-respecting individuals of this sort), and first and foremost to
Vanghelis, behind me on the right, whose genius would appreciate
more than anyone the aporia called "translation" (and I still hope that
he will agree to translate this text, for nothing better could happen to
these words in Greek).

I began explaining to my friends the different ways in which, for me,
nous nous devons à la mort would forever remain photographed, in some
sense, in the French language. The grammatical resources of this sen-
tence lent to its logic, an innocently perverse logic, perverse despite it-
self, a desperate taste of eternity, lending this taste then to us, who, at
that moment, felt our desire being burnt by a sun the likes of which I
had never known. There was but one sun, and it had only a homonymic
relation with all the others. Over the road that led us back to Athens,
that Wednesday, July 3, 1996, there blazed a sun like no other I had
ever known. We were coming back from Brauron, where we had seen
the Chapel of Saint George, with its small ritual drinking cups deco-
rated with young naked girls running or virgins in a procession toward
the altar of Artemis, the so-called votive bas-relief "of the gods" (Zeus,
Apollo, Artemis—Iphigenia in absentia), statues of young girls (*arktos*),
Artemis the huntress, Artemis on her throne, Artemis Kourotrophos,
the remains of the necropolis of Merenda (on the rim of an amphora I
recall an "exposition of the dead"), and we were going to go swimming.
I had to take a plane later that day; delay was on the day's agenda, and

· 28 ·

we were laughing about it. My friends know that if I love delayed action [*le retardement*], the least delay kills me, especially when I am about to leave for the train station or the airport, that is, at the moment of arriving at the point of departure. I began to explain all these reasons why, for me, *nous nous devons à la mort* would remain forever untranslated, spelled out, photorthographed in an album of the French language.

First, it did not necessarily have to be understood in the sense of the great post-Socratic and sacrificial tradition of being-for-death, this ethics of dedication or devotion that immediately comes to take this sentence into its purview in order to say, for example: we must devote ourselves to death, we have duties with regard to death, we must dedicate our meditations to it, our care, our concern, our exercises and our practice (*epimeleia tou thanatou, meletē thanatou*, as it is said at *Phaedo* 81a), we must devote ourselves to the death to which we are destined, and so on. In addition, one must respect the dead (so as, the implication would be, to keep death at a respectful distance, out of a respect for life). It is the death of Socrates, in short, that never stops watching over us, the culture of death or the cult of mourning, the way in which this poor Socrates, between the verdict and the passing of the sails off Cape Sounion, believed that by not fleeing or saving his skin he was saving himself and saving within him, at the same moment, philosophy, all that music that is philosophy, "the greatest kind of music." But as for me, I persist in believing that philosophy might have another chance. This ethico-Socratic virtue of "we owe ourselves to death" can easily be translated into every language and no doubt every "world view." But that is not the only meaning that is held in reserve in my sentence, and I protested silently against it.

As for the redoubling of the *nous* in *nous* nous *devons*, it is no doubt difficult, if not impossible (I mean according to the economy of a word-for-word translation), to retain in another language its relation to the

sole and irreplaceable word *devons*, which suspends, in some sense, its status as a grammatical subject or as a subject at all. What I wanted to suggest to my friends would be, in short, the following: the first *nous*, the "subject," would come after the second one (the reflecting object, the one taken in view, shot, the one that begins to look at us from over there, like a "photographed" object). It would constitute itself as "subject" only after having reflected the "second" *nous*, which is itself constituted as an "object" *due* or *owed*: *nous*, we, are "due" (moratorium, delay, giving notice), we appear to ourselves, we relate to ourselves, we take ourselves in view as what is due [*dû*], taken by a debt or a duty that precedes us and institutes us, a debt that contracts us even before we have contracted it. Taken by surprise in this *nous*, I would be from the outset situated, already a fetish, merchandise, a pledge or a hostage, something promised or something due in the exchange, something traded in the transaction (a bit like the fish or meat for sale in all these Athenian markets). And all the figures of autonomic obligation that govern our morality or our ethics would be taken in view, shot, by this originary heteronomy.

To what, then, would we owe ourselves? To whom? To death, which would be someone or something? And in owing ourselves, owing *ourselves* rather than this or that, do we owe all or nothing? Or do we owe ourselves, are we ourselves due, to death, which is nothing? Due, then, to nothing and to no one? Or else to some dead person, him or her, some particular death? Who knows. (The English phrase "to be due to" perhaps conveys rather well this intertwining of debt, duty, obligation, and what comes due at a specific date, at a particular moment in time, at the appointed time.)

But that is not all, and it is not even what's essential, for this might *still* be translated into a common idiom (Nietzschean, Heideggerian, or Lacanian). What this French sentence, this sentence that took me

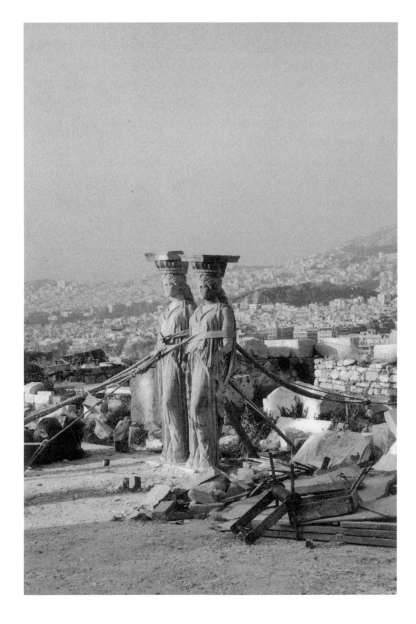

by surprise in the sun, would forever leave suspended, better than any other sentence, more economically than any other, is the *pragmatic modality* of its event. For it came alone, this sentence did, as decontextualized as a photograph. It was thus impossible to decide, without any other context, as if its inscription were being read on a piece of funerary stone or on its photograph, whether it was a matter of an ethico-philosophical exhortation, with the performative potentiality that comes along with it, or a constative description, or even an indignant protestation that would raise the curtain on centuries of deception and obstinacy: So (you say that, it is believed that, they claim that) "we owe ourselves to death"!--well, no, we refuse this debt; not only do we not recognize it, but we refuse the authority of this anteriority, this a priori or this supposed originarity of obligation, of *Schuldigsein*, this religion of mourning, this culture of loss and of lack, and so on. (The *and so on* is essential here, for it signs the suspension, signs the "photographic" structure, the decontextualized aphorism of this sentence that assailed me on that day, around noon, in full sunlight, in the domesticity of my old love affair with this stranger whom I call my French language.) Against this debt, this obligation, this culpability, and this fear of the dead, a "we" might, perhaps, protest (and this would not necessarily be me, me or some other *me*); we might be able to protest innocently our innocence, one "we" protesting against the other. *Nous nous devons à la mort*, we owe ourselves to death, there is indeed a *nous*, the second one, who owes itself in this way, but we, in the first place, no, the first *we* who looks, observes, and photographs the other, and who speaks here, is an innocent living being who forever knows nothing of death: in this *we* we are infinite—that is what I might have wanted to say to my friends. We are infinite, and so let's be infinite, eternally. It is, in any case, from this thought, beneath the sun, at the moment of returning to Athens, that we could at least dream of pronouncing,

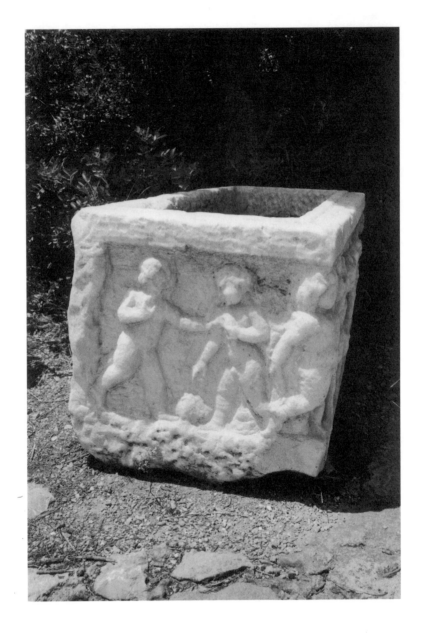

and summoning to appear, but in the mode of a denunciation, the little sentence "we owe ourselves to death." The sun itself is finite, as we know, and its light might one day come to an end, but us? Let's leave finitude to the sun and return in another way to Athens. Which would mean: there is mourning and there is death—notice I am not saying memory, innocent memory—only for what regards the sun. Every photograph is of the sun.

Still XVIII

Is not this impassioned denunciation the last sign of mourning, the sunniest of all steles, the weightiest denial, the honor of life in its wounded photograph?

Still XIX

So many hypotheses! What could have been going through the head of this photographer on the Acropolis? Was he sleeping? Dreaming? Was he simply pretending, feigning the whole thing? Was he playing dead? Or playing a living being who knows he has to die? Was he thinking of everyday Athens, of the Athens of today, or of the Athens of always, *aei*? Was he already haunted by the stratified ruin of all the Athenian memories he would have wanted to take in view, to shoot, this day, today, under this sun, but for every day and forever? Or was he haunted by what took place, one fine day, between photographic technology and the light of day? Or else by what took place, one day, between photography, the day or night of the unconscious, archaeology, and psychoanalysis? Would he recall, for example, a certain "disturbance of memory on the Acropolis?" ("Eine Erinnerungsstörung auf der Akropolis," 1936), which I have never stopped thinking about, especially

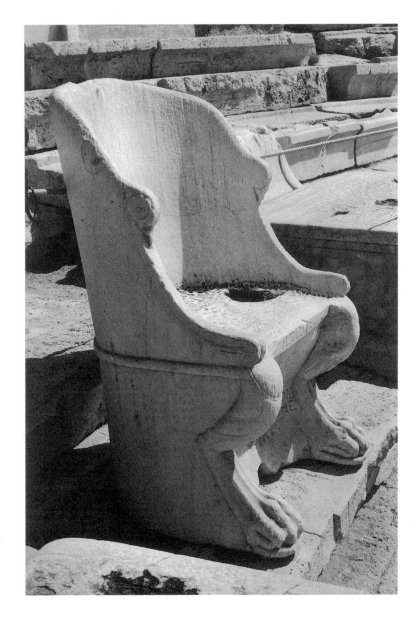

at the point where Freud meditates upon what he calls in French the *"non arrivé"*?[7]

One might as well ask what takes place when, photographed in the process of photographing (himself), photographed photographing, active and passive at the same time, in the same time, that is, during time itself—which will always have been this auto-affective experience of passactivity—a photographer takes a shot of himself. One might as well ask what happens to him, and to us, when his action thus takes up taking itself by surprise, but without ceasing to await this surprise. He awaits (himself), this *bonhomme* does, this good fellow photographer. Right there in the theater of Dionysus, he reckons with the incalculable. I then dream his vision, the fire of a declaration of love, a flash in broad daylight, and one would say to the other: "It takes me by surprise to be waiting for you today, my love, as always." Dionysianism, philosophy, photography. It remains to be known *what is (ti esti)* the essence of the photographic form from the point of view of a delay that gets carried away with overtaking time. A silent avowal, perhaps, and reticent as well, because it knows how to keep silent, an infinitely elliptical discourse, mad with a single desire: to impress time with all times, at all times, and then furtively, in the night, like a thief of fire, archive at the speed of light the speed of light.

· 33 ·

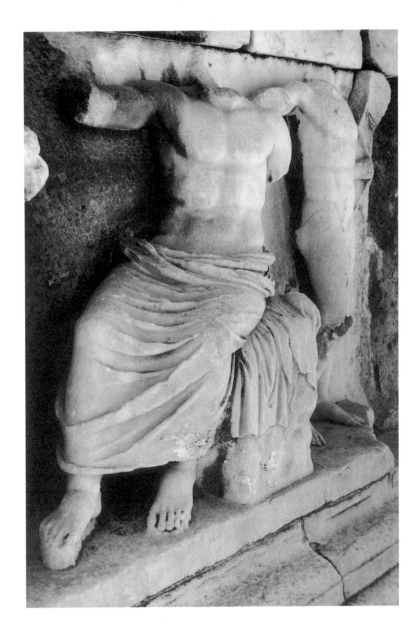

Still XX

Return to Athens. Let one not hasten to conclude that photography does away with words and can do without translation, as if an art of silence would no longer be indebted to a language. "After all," the tourist of photographs will say, "these images of Athens are all the more precious to me insofar as they speak to me in a universal language. If they remain untranslatable and untranslatably singular, it is because of their very universality; they show the same thing to everyone, whatever their language may be: the divine play of shadow and light in the Kerameikos Cemetery, in the Agora, the Acropolis, the Parthenon, the Adrianou Street Market, the pause of a photographer before the name Persephone."

No, photographs are untranslatable in another way, according to the laconic ruse of a specter or a phantasm, when this economy acts as a letter, when it succeeds in saying to us, with or without words, that we owe ourselves to death.

—We? What "we"? And, first of all, who is included in this we? Like a negative still in the camera, an impressed question remains in abeyance, still pending. Will it ever be developed? Who will have signed the *nous*, whether the first or the second, of this *nous nous devons à la mort*? Me, you, she, he, all of you? And who will have inherited it in the end?

—But I am reading this in translation, am I not? It was written in French and I am reading it in English[8] ...

—What does that prove? Every time you look at these photographs, you will have to begin again to translate, and to recall that one day, around noon, for some, having come from Athens and on their way back to it, the verdict had come down but the sun was not yet dead.

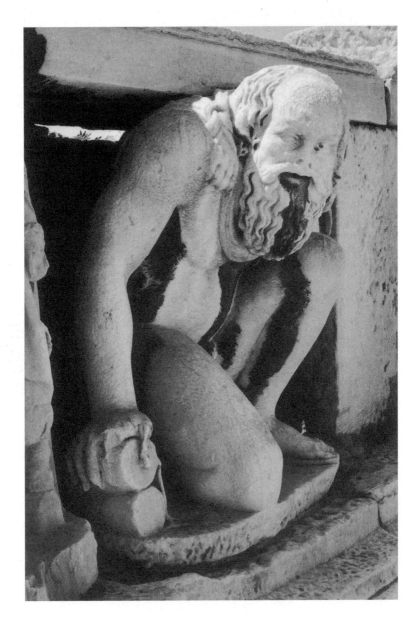

Notes

1 The phrase *nous nous devons à la mort* comes from the first person plural form of the reflexive verb *se devoir à*. *Collins Robert Dictionary* gives as its only example of this reflexive form: *une mère se doit à sa famille*, "a mother has to *or* must devote herself to her family." Hence *nous nous devons à la mort* would mean "we must devote ourselves to death" or, as we have translated it throughout, "we owe ourselves to death." But following Derrida's suggestion in *Right of Inspection* that the phrase *elles se regardent* be heard as either a reflexive relation, "they look at themselves," or a reciprocal one, "they look at one another," *nous nous devons à la mort* might also be read as expressing a reciprocal relation: "we owe each other *or* we owe one another to death (or up until death)." While we have translated this phrase as a reflexive throughout, the reader may want to experiment with this other possibility, especially in Still XVII.—Trans.

2 In addition to the meaning it carries in English, the French word *cliché* can mean either a photographic negative or plate or else, more generally and more colloquially, a photograph. Derrida gives the title *cliché*—which we have translated as "still"—to each of the twenty sections of his commentary.—Trans.

3 What a word is right. Though the adverb *incessamment* typically means in modern French not "incessantly" but "what is about to happen, what is on the verge of happening, what could happen at any moment," it is occasionally used in French letters to mean "without interruption or pause," that is, "continually or incessantly." In what follows Derrida seems to be trading on both senses of the term.—Trans.

4 *Crito* 43c–44b; trans. Harold North Fowler (Cambridge: Harvard University Press, 1982). Translation slightly modified.

5 Ibid., 59d-e.

6 *Phaedo* 61a-b; trans. Harold North Fowler (Cambridge: Harvard University Press, 1982).

7 Sigmund Freud, "A Disturbance of Memory on the Acropolis," in *The Standard Edition of the Complete Works of Sigmund Freud*, trans. under the editorship of James Strachey, in collaboration with Anna Freud (London: The Hogarth Press and the Institute of Psycho-analysis, 1964), 22:239–48; the phrase *non arrivé* can be found on p. 246.

8 The French text reads here *en grec*—"in Greek"—since, as we learn from Still XVII, Derrida was anticipating the Modern Greek translation of this work.—Trans.